I ♥ COLORING

PSS!

PRICE STERN SLOAN

An Imprint of Penguin Random House

PRICE STERN SLOAN
Penguin Young Readers Group
An Imprint of Penguin Random House LLC

Illustrated by Felicity French, with additional material adapted from www.shutterstock.com.

Copyright © 2015 by Buster Books.
First published in Great Britain by
Buster Books, an imprint of
Michael O'Mara Books Limited.

First published in the United States of America in 2015 by Price Stern Sloan, an imprint of Penguin Random House LLC, 345 Hudson Street, New York, New York 10014.

PSS! is a registered trademark of Penguin Random House LLC.
Printed in Canada.

ISBN 978-0-399-54128-5

10 9 8 7 6 5 4 3 2 1

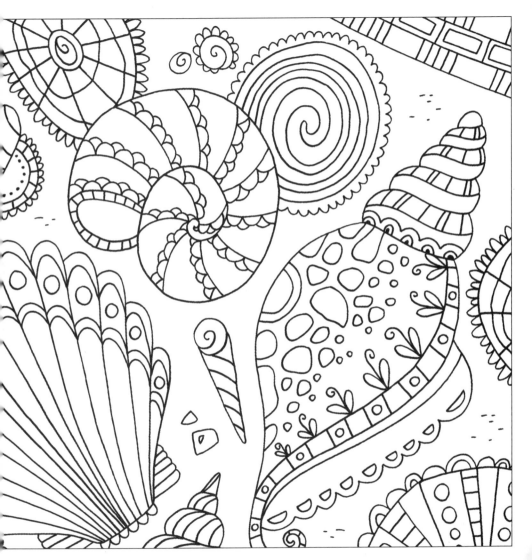

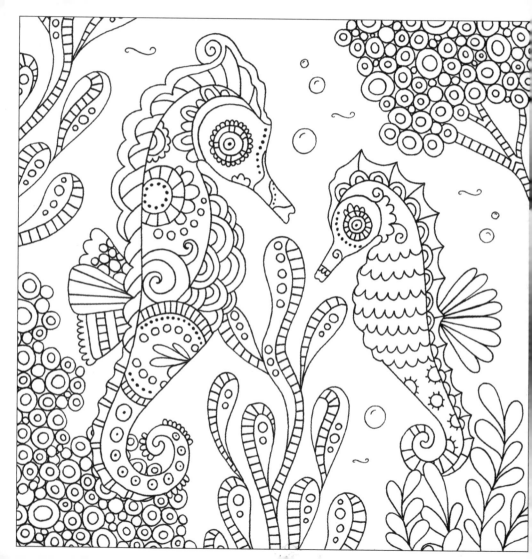

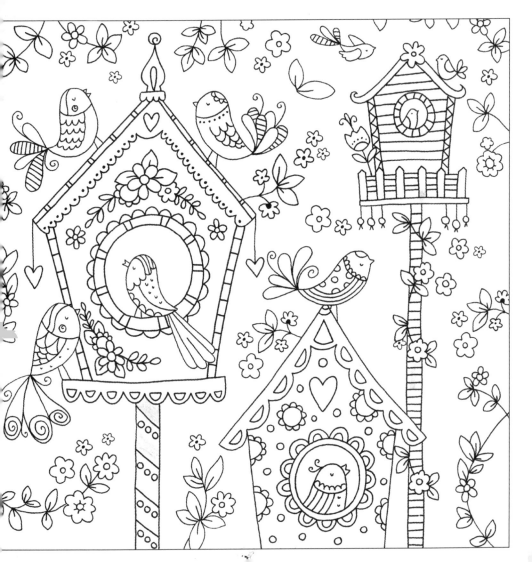

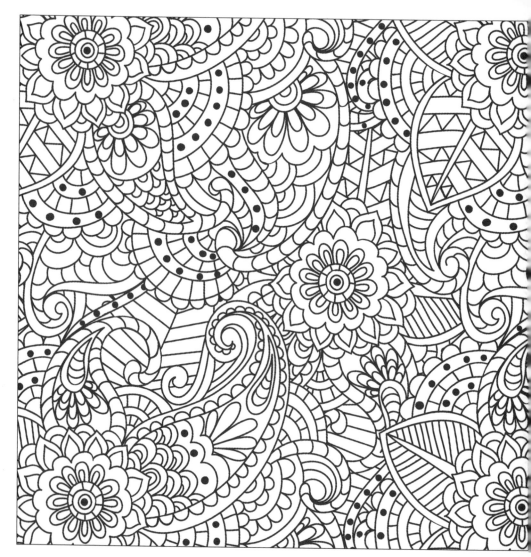

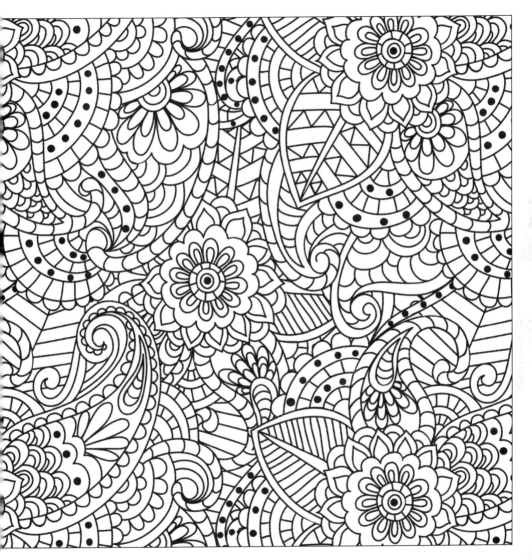

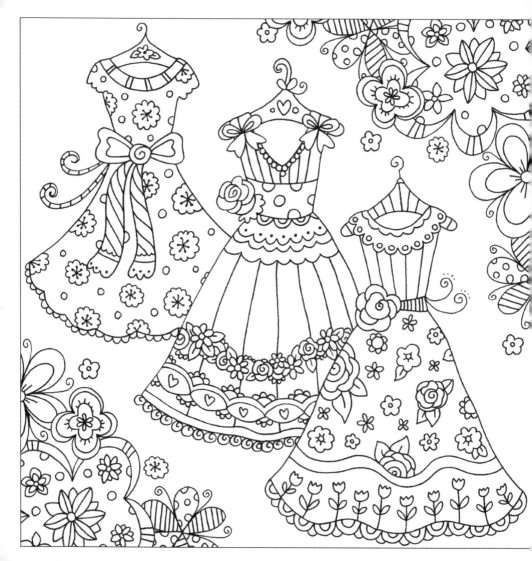

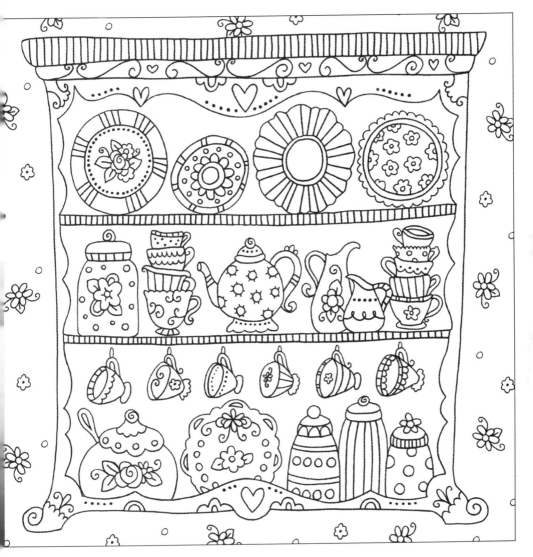

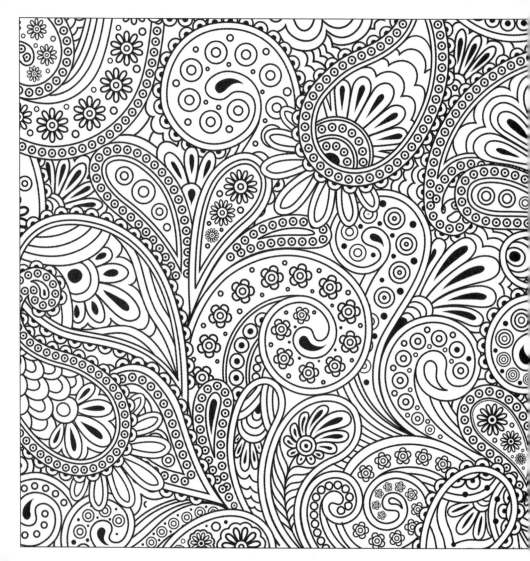

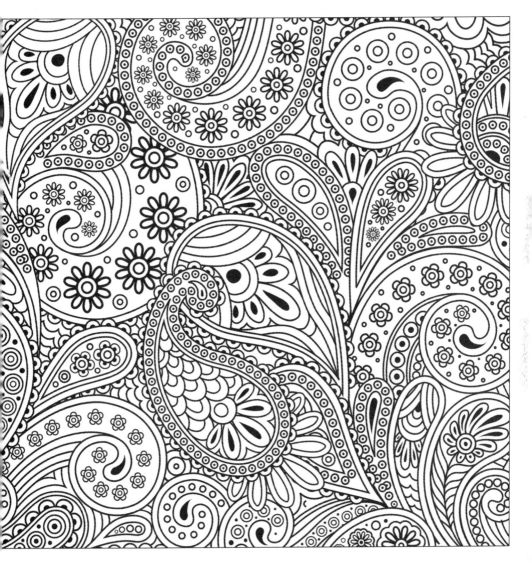

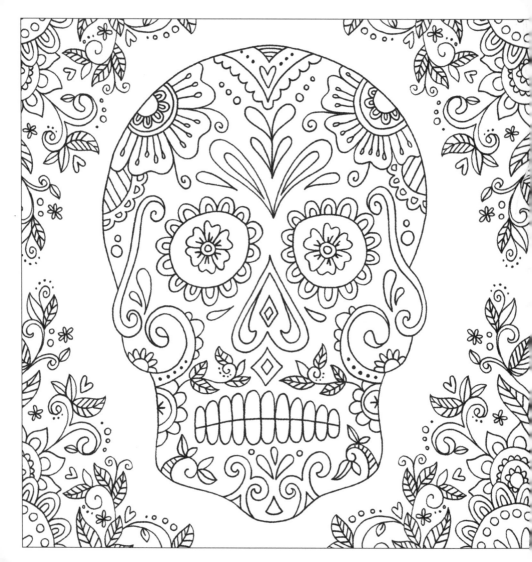

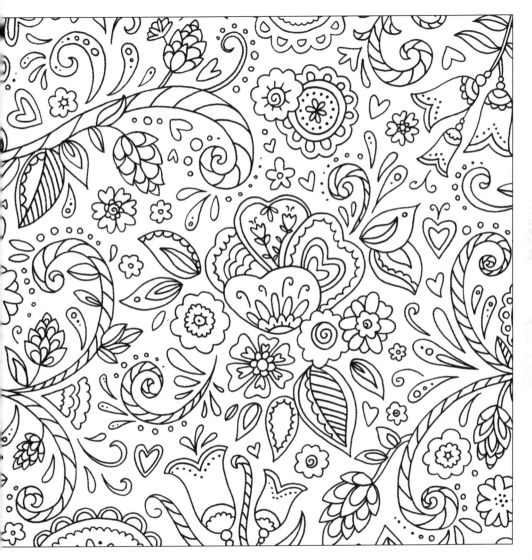

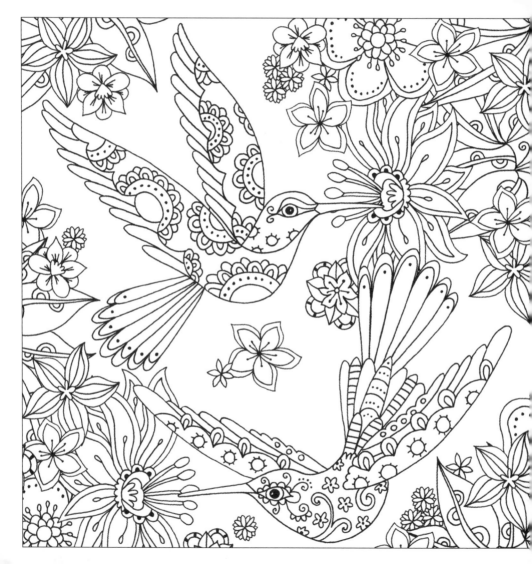

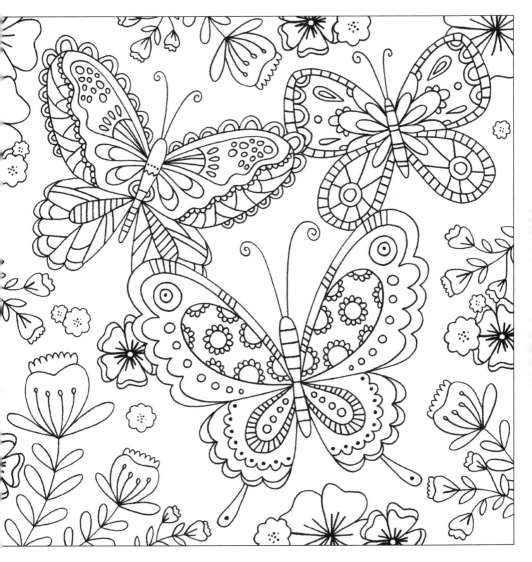

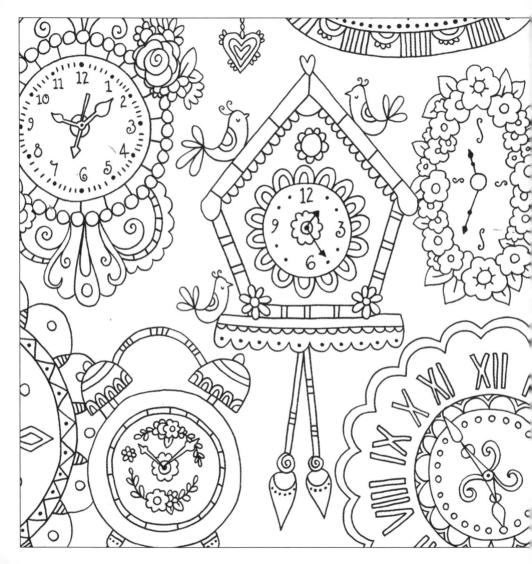

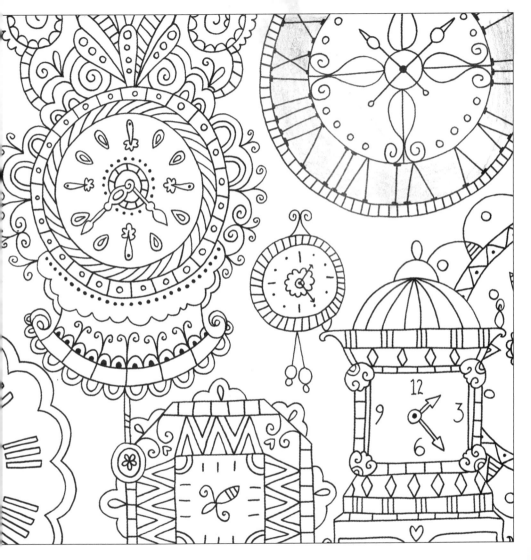

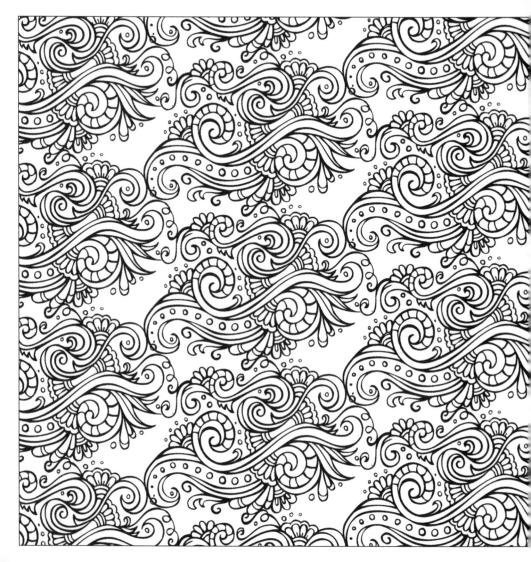

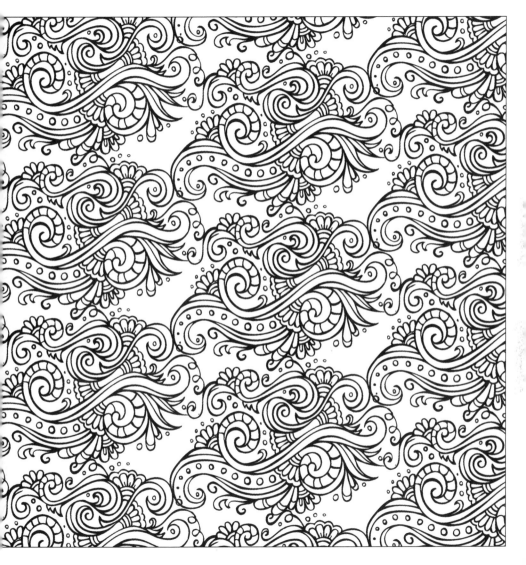

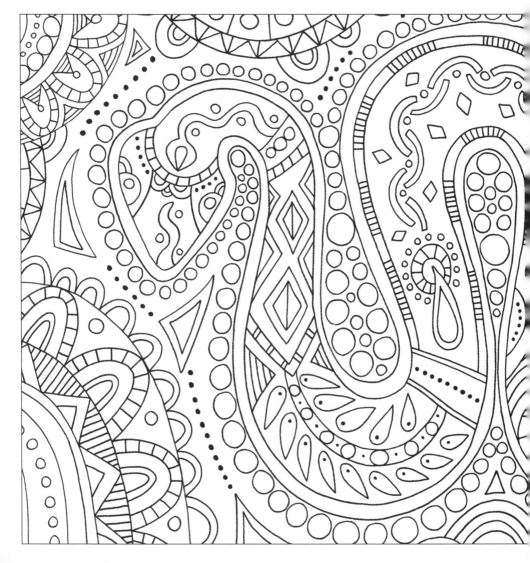

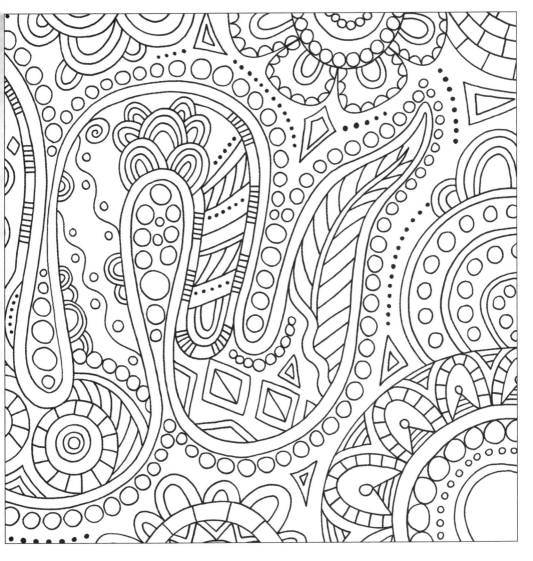

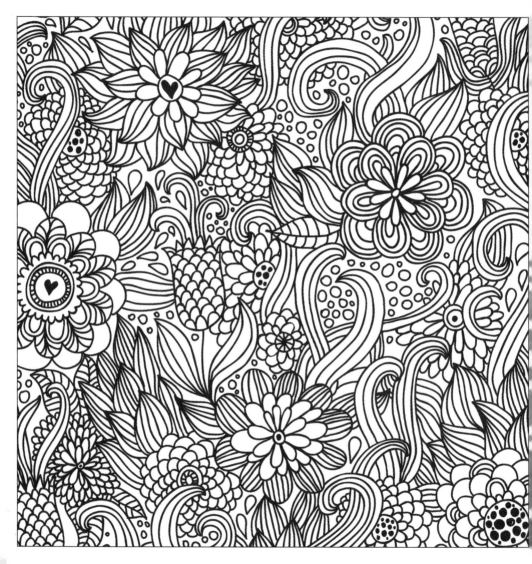

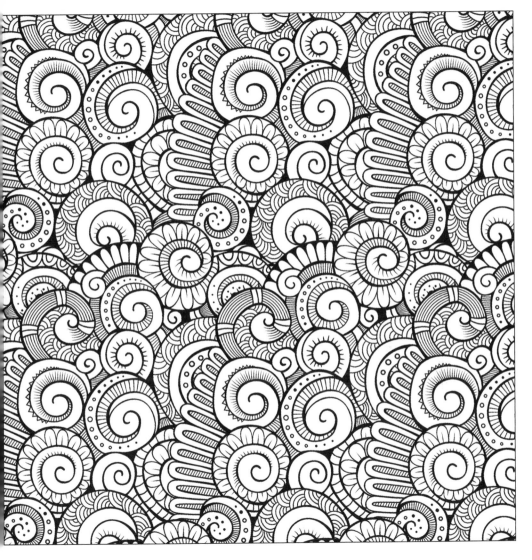

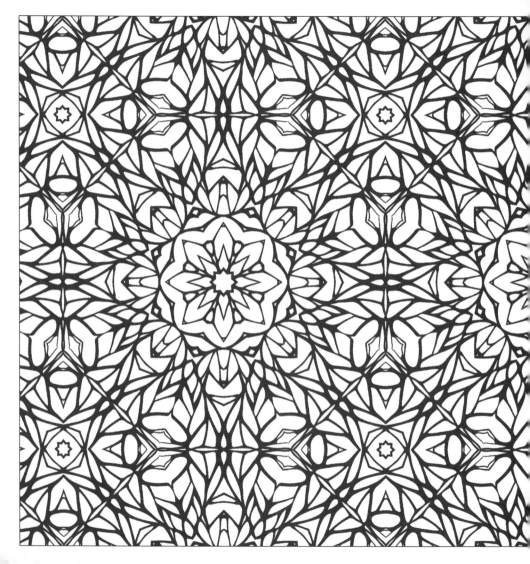

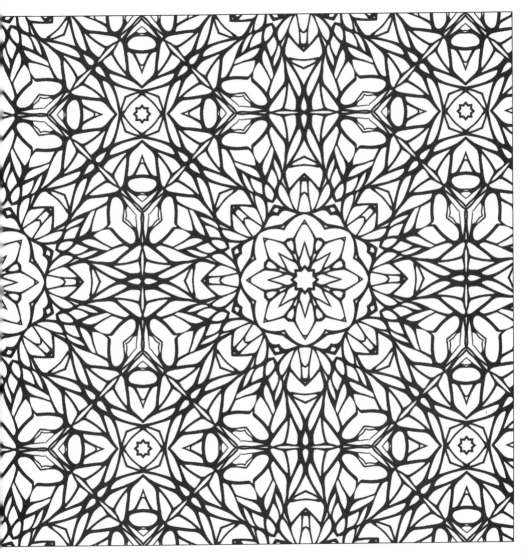

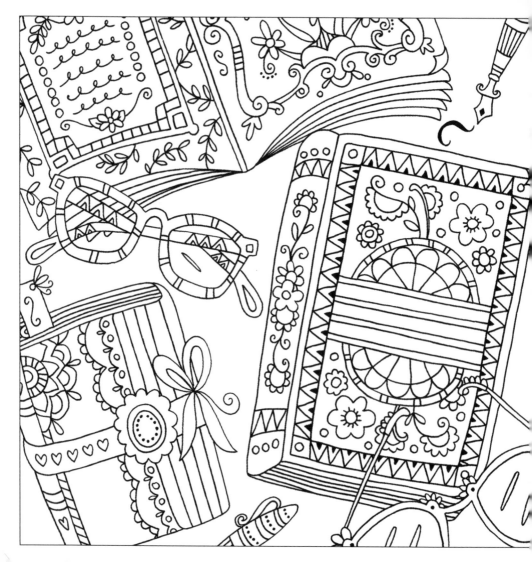

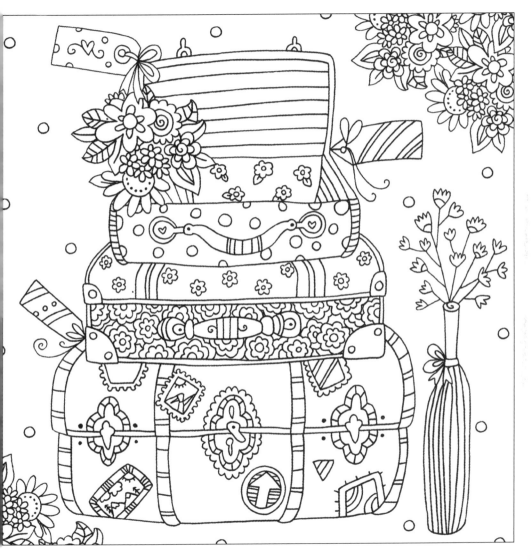

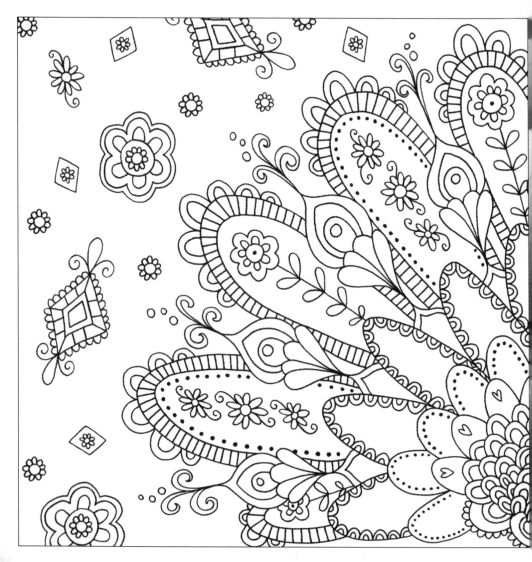

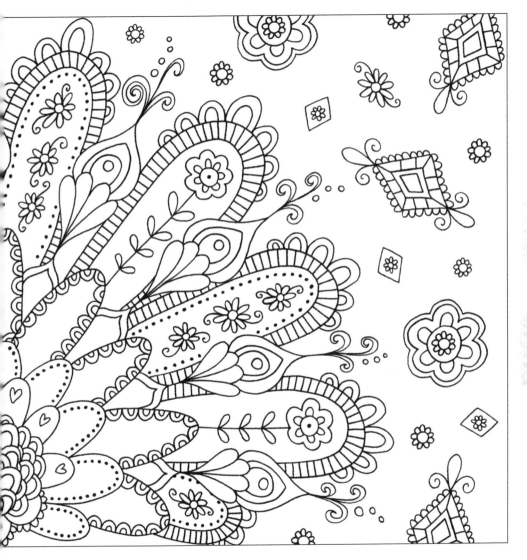

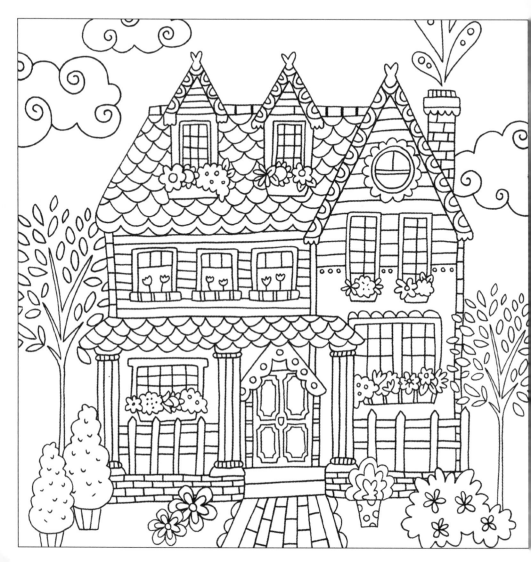

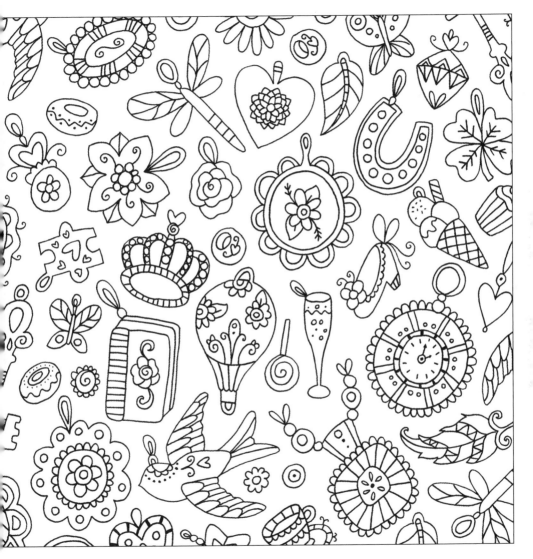

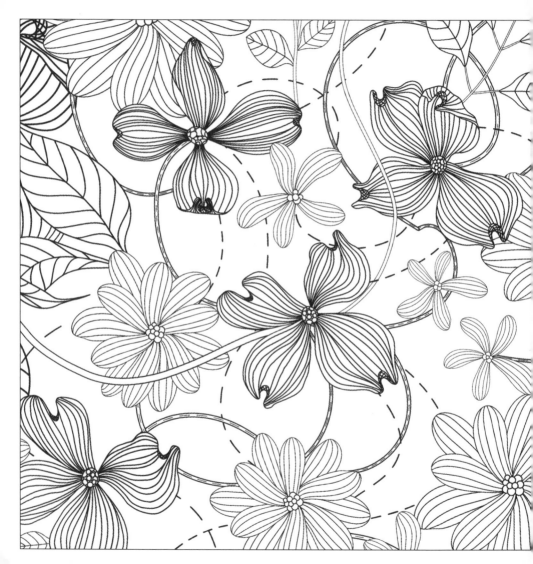

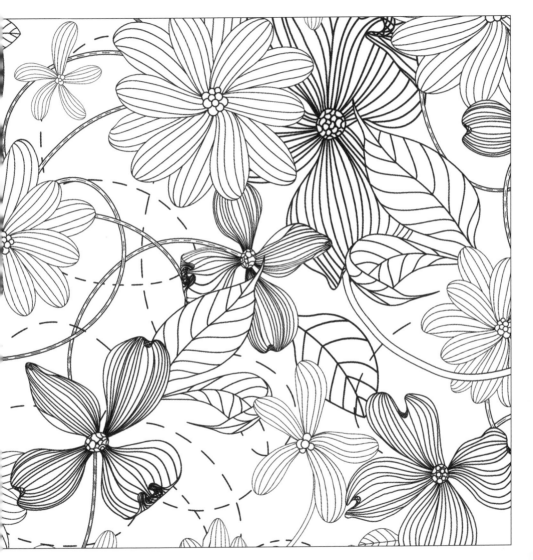

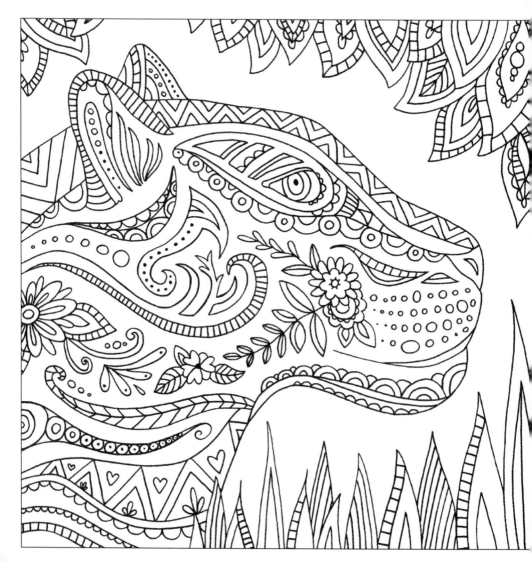

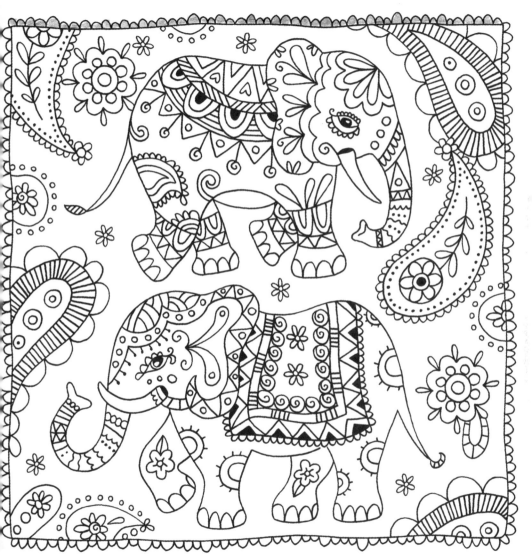

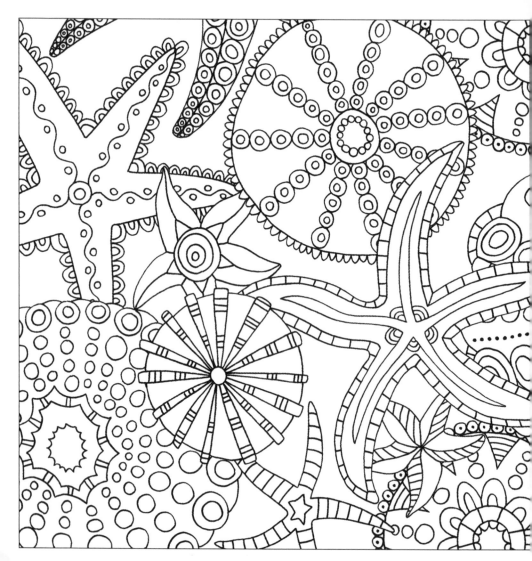

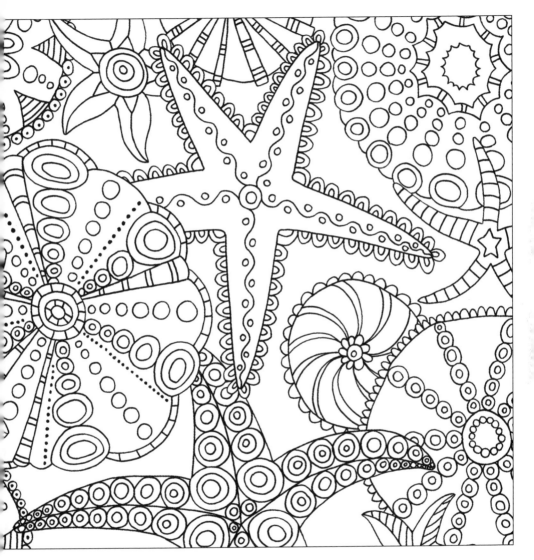

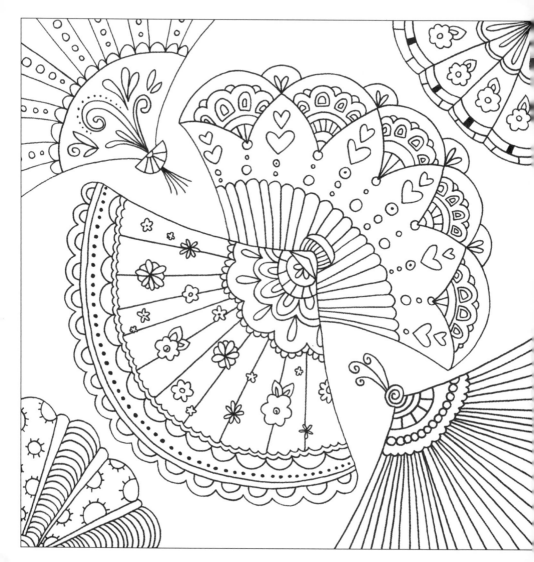

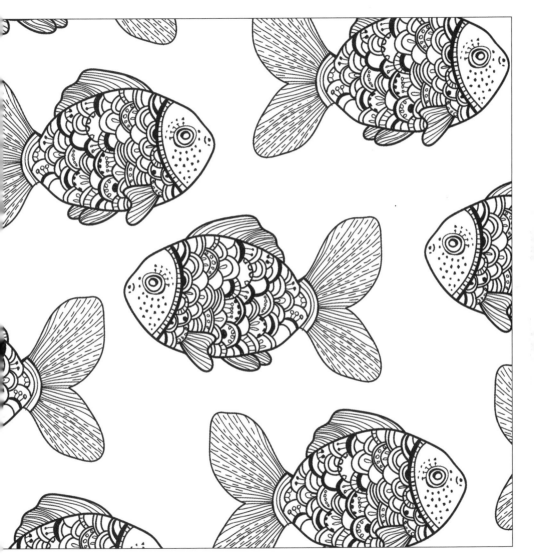

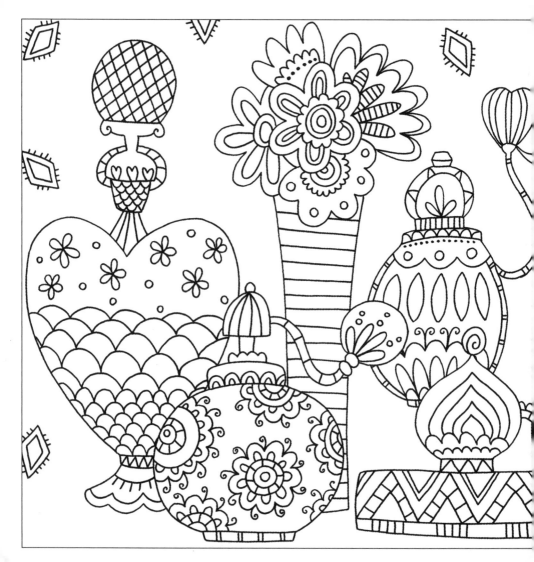

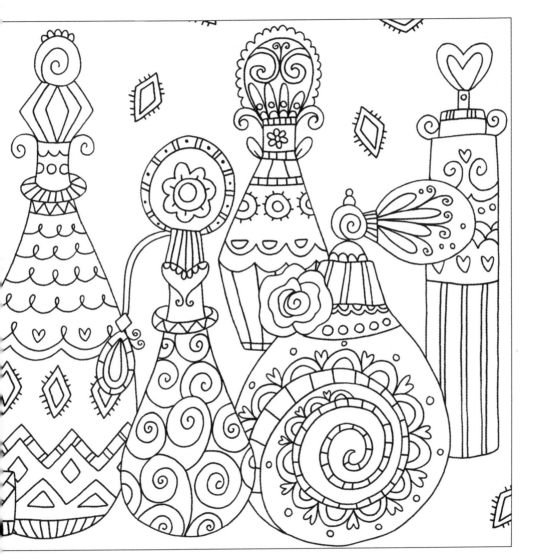

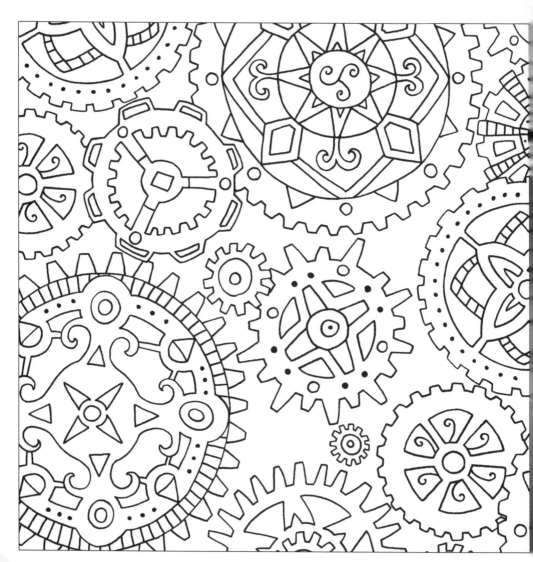

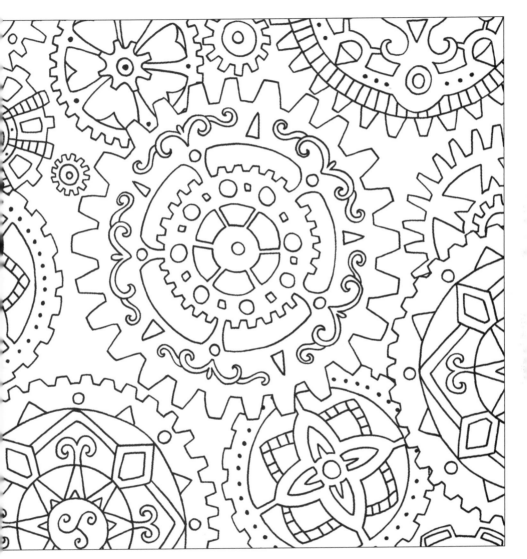

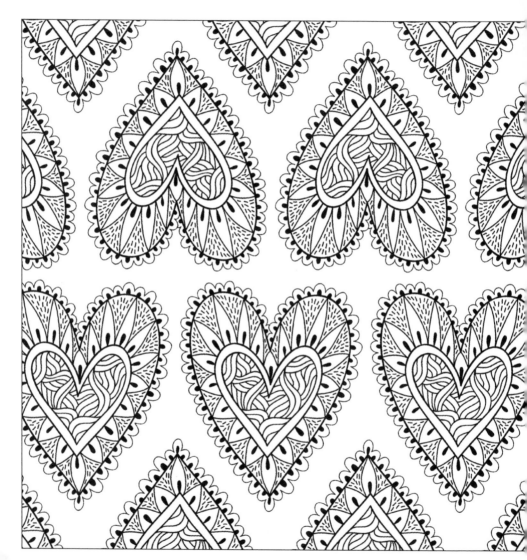

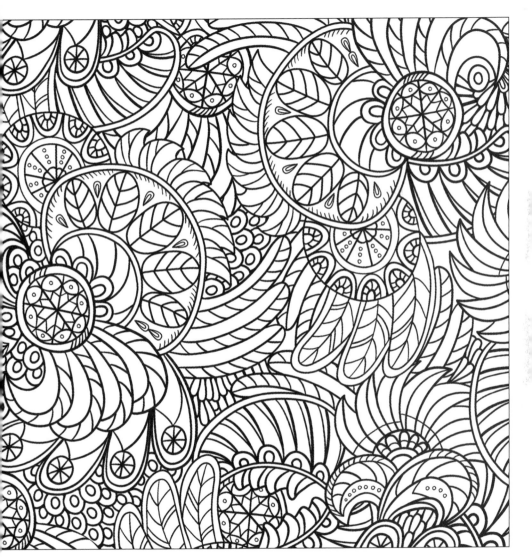

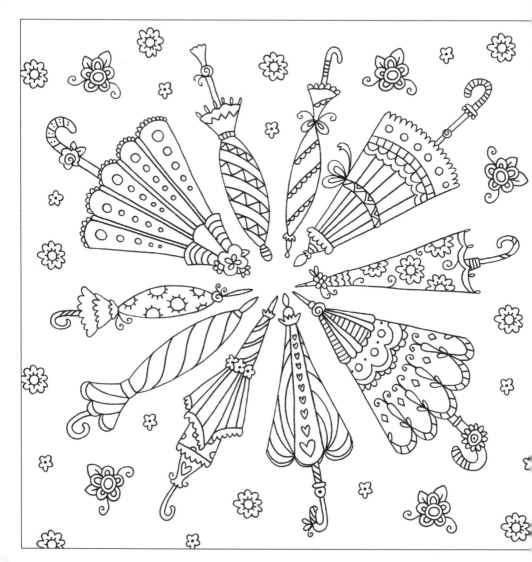

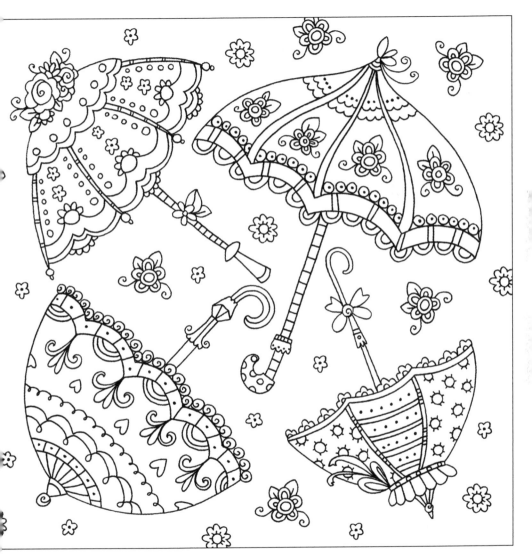

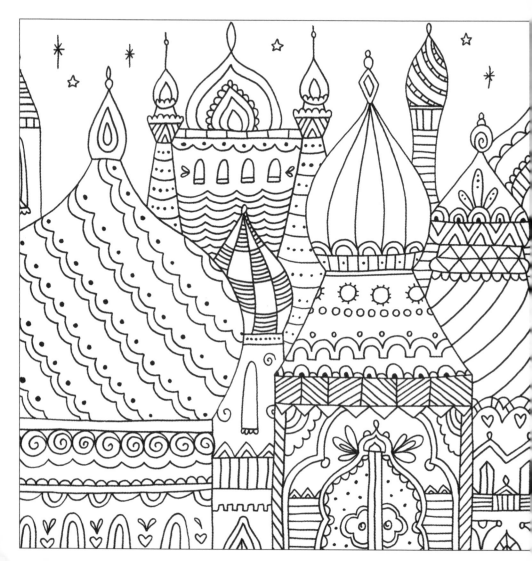

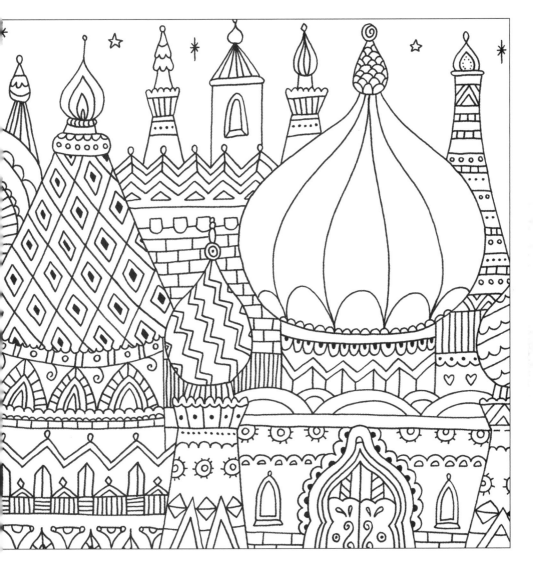

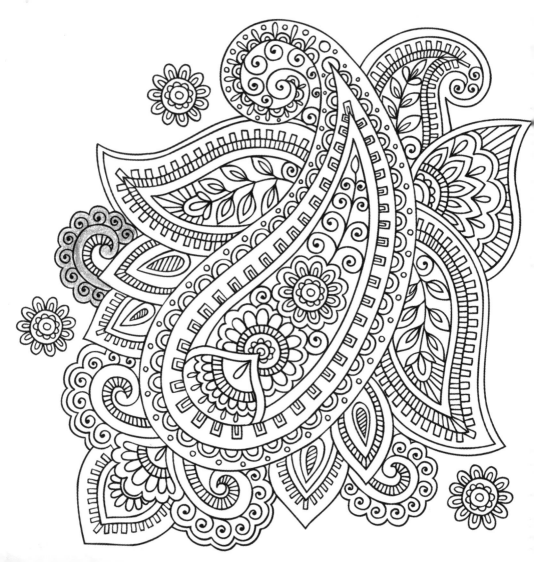

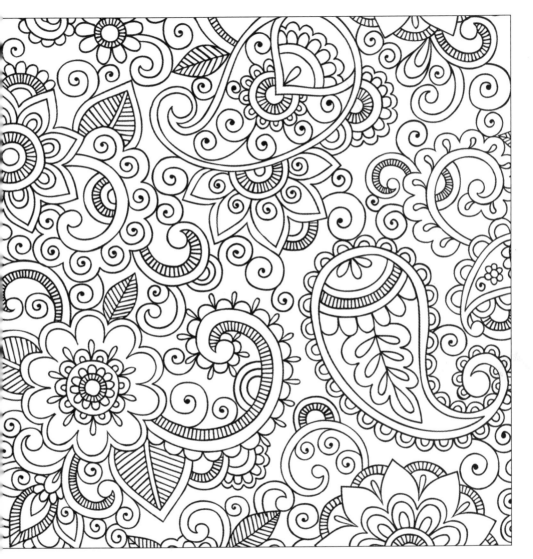

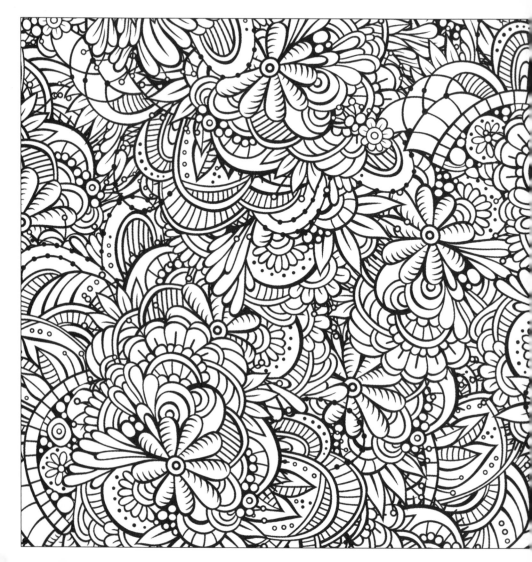

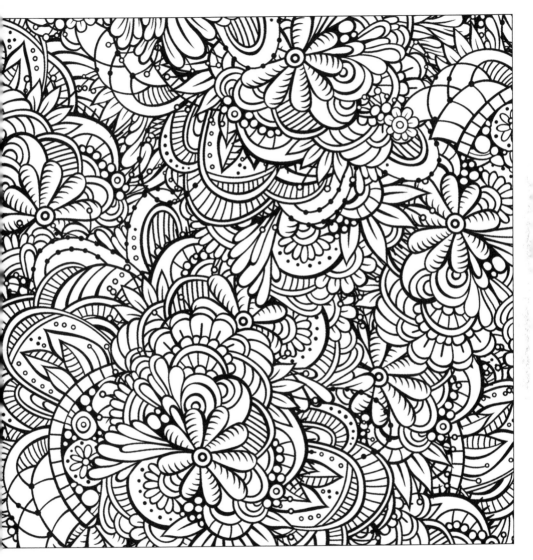

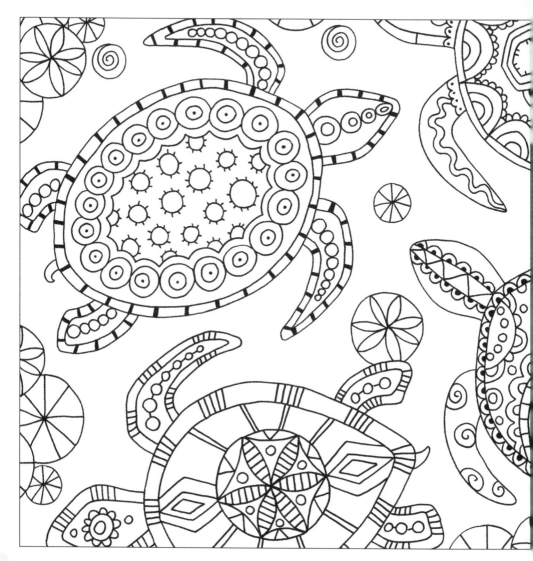

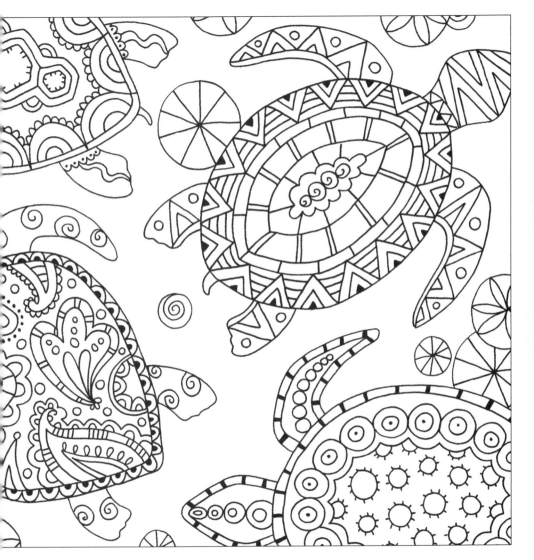

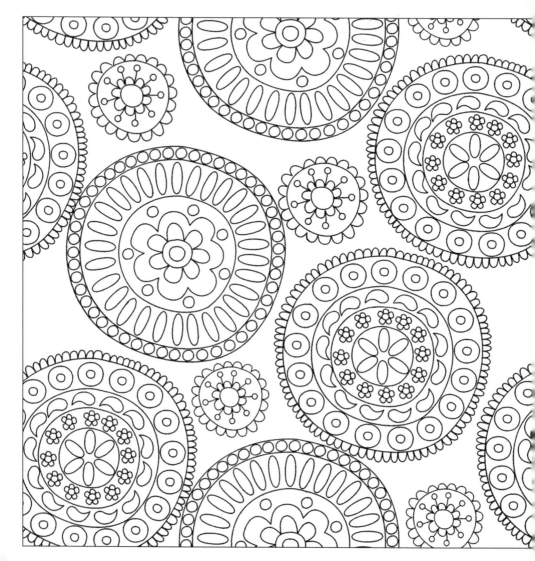

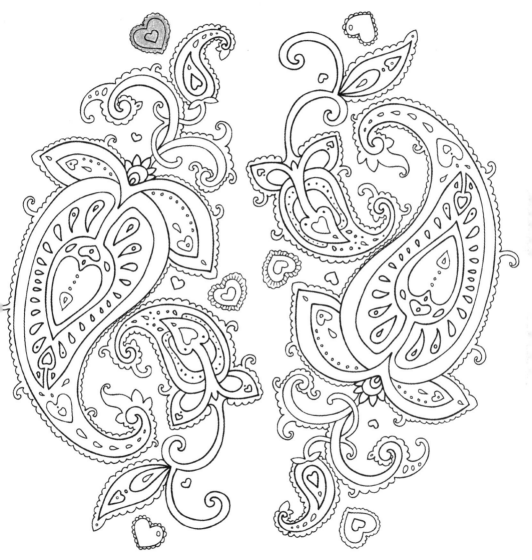

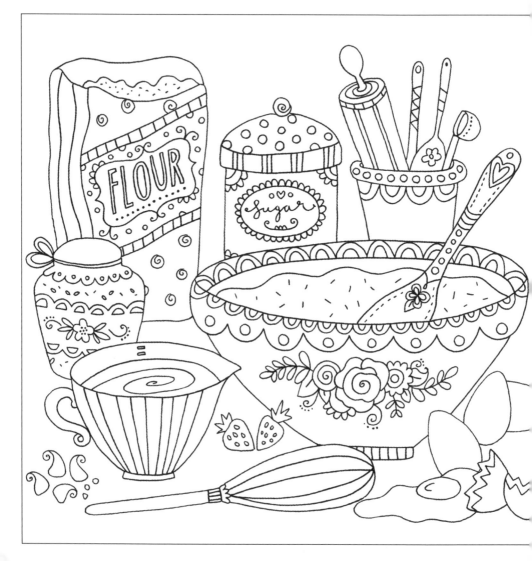

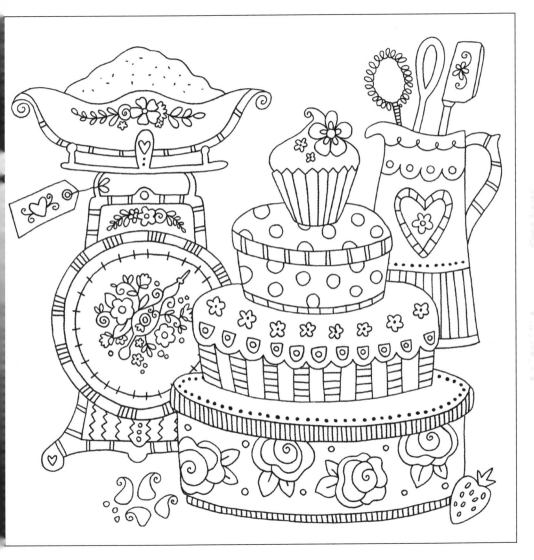

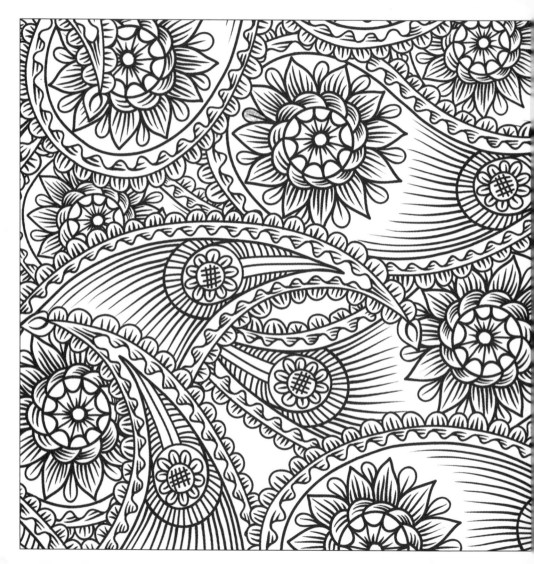

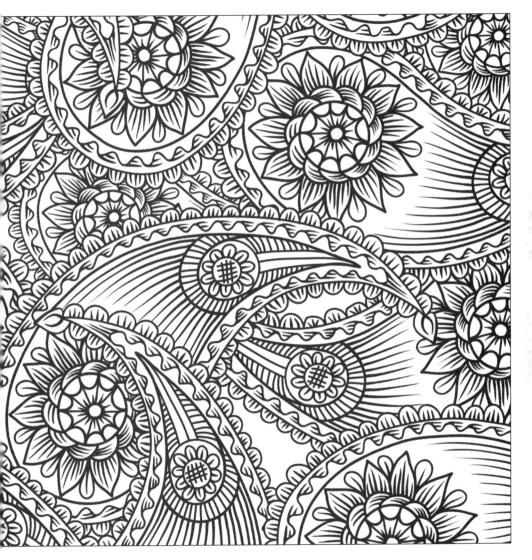

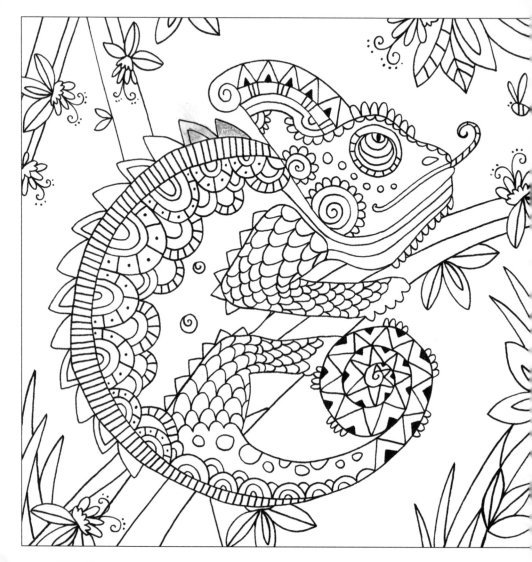

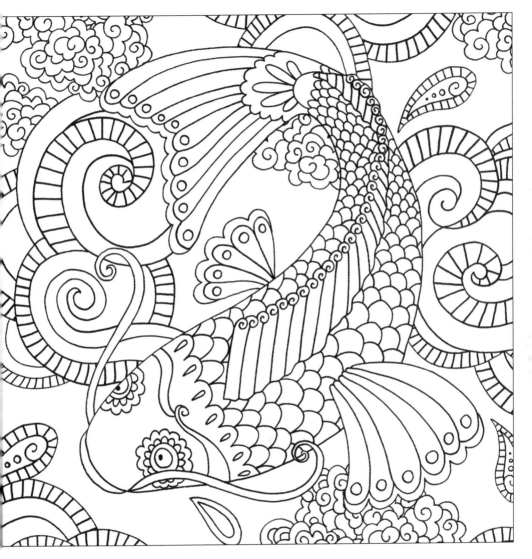

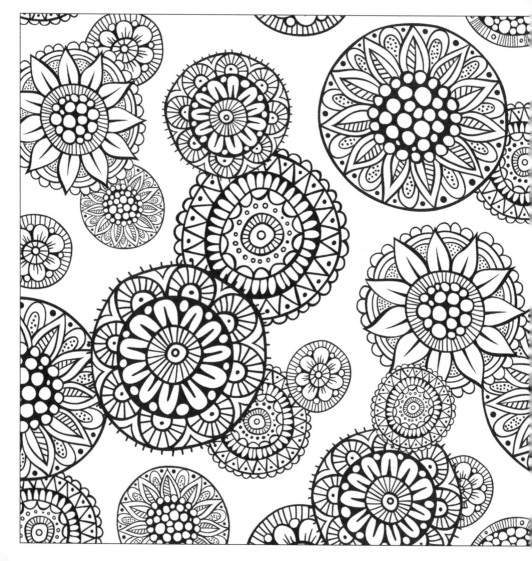

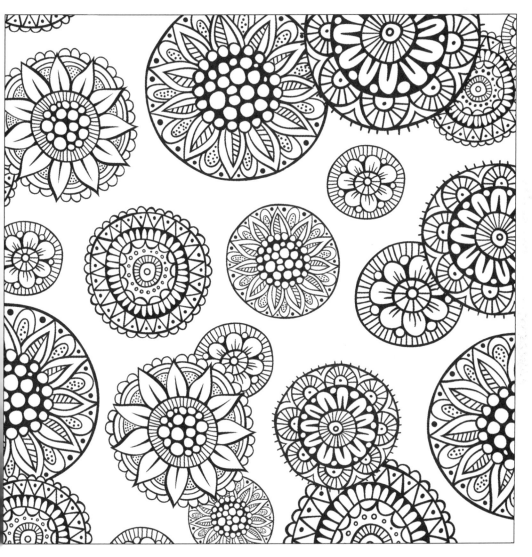

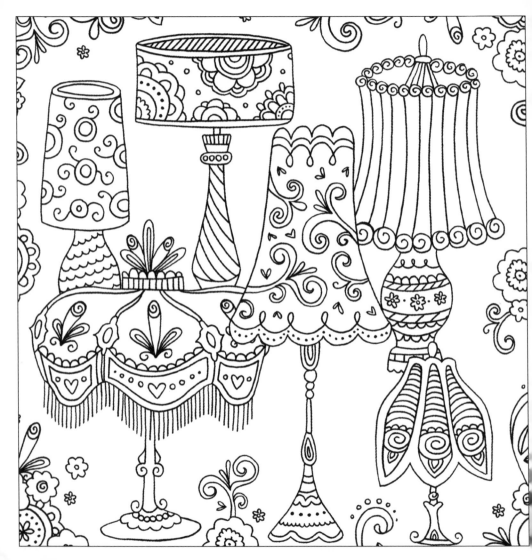

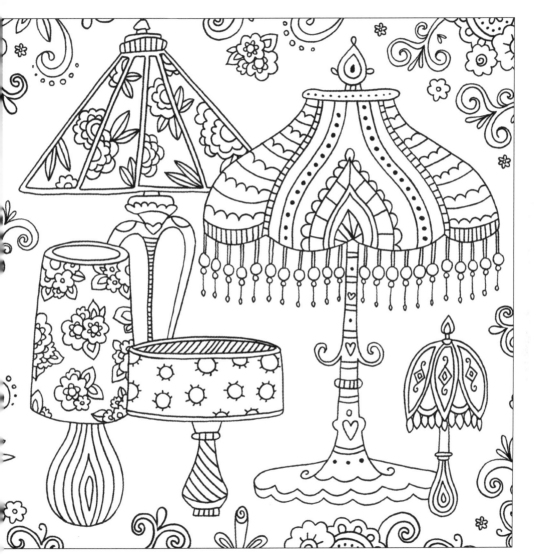

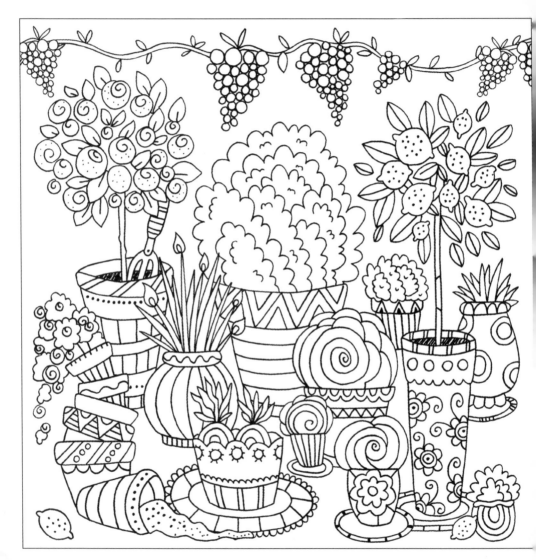

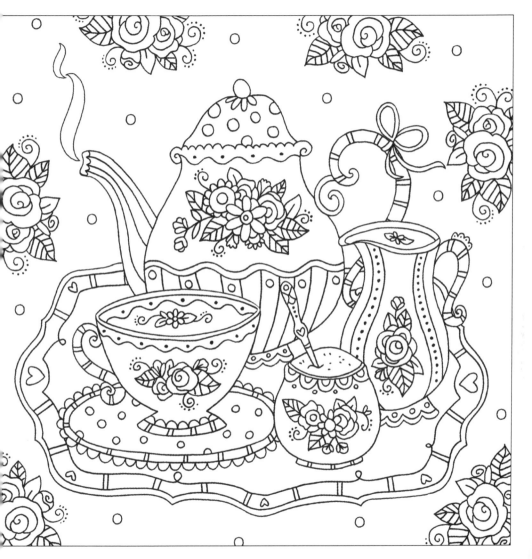

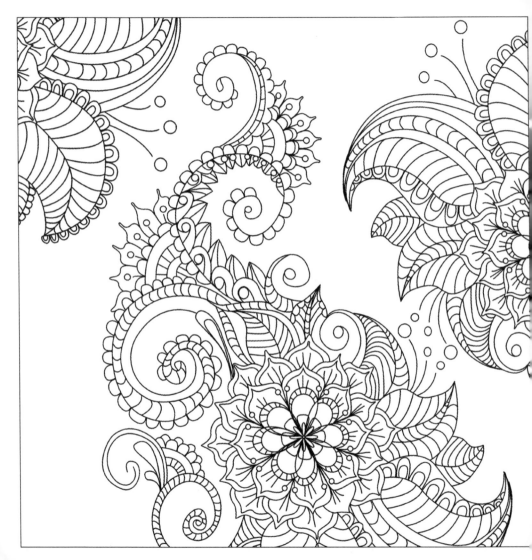

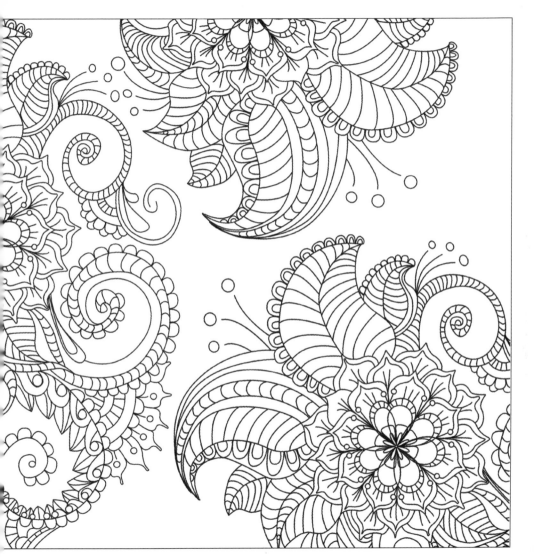

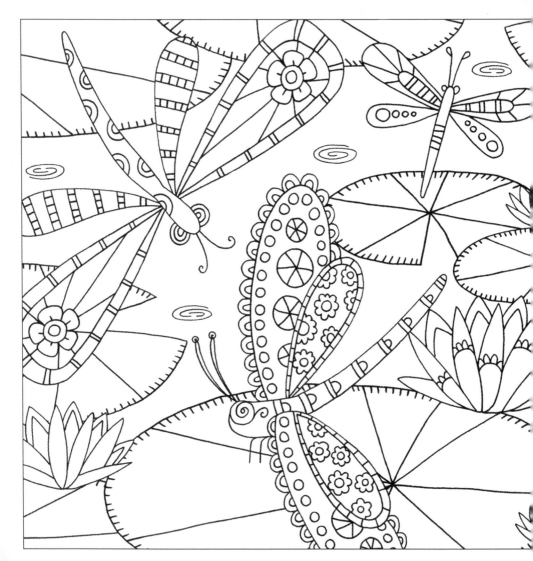

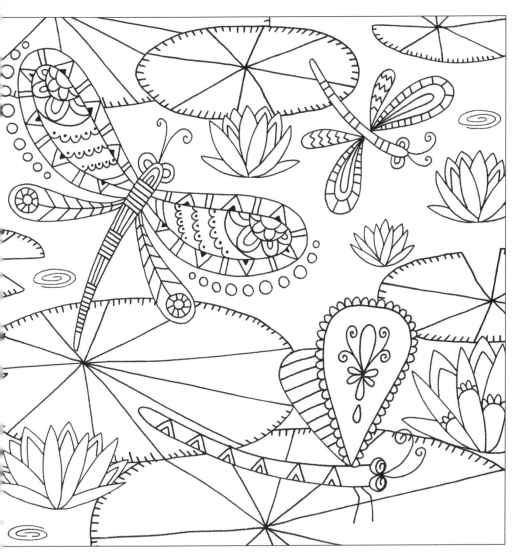

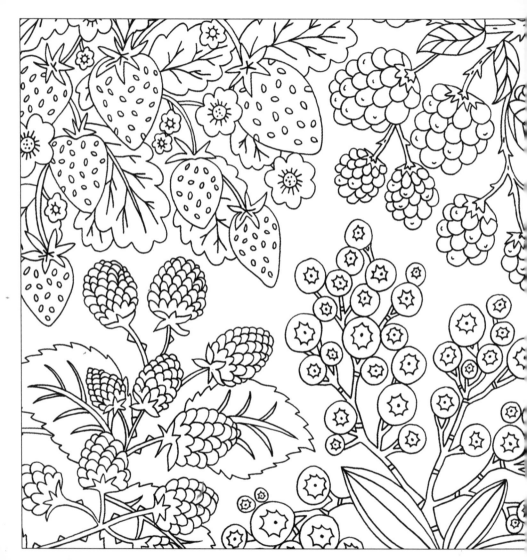

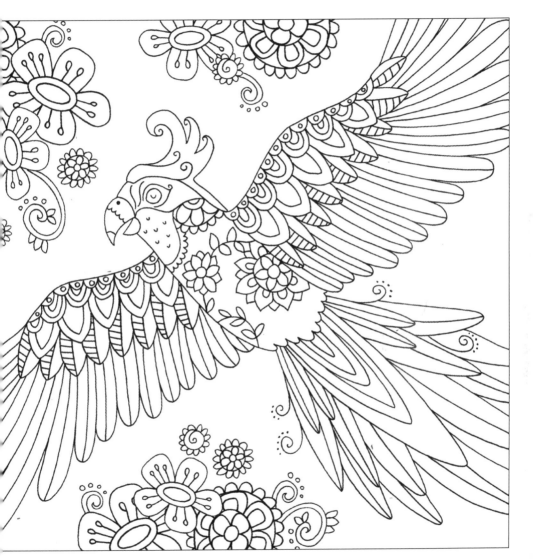

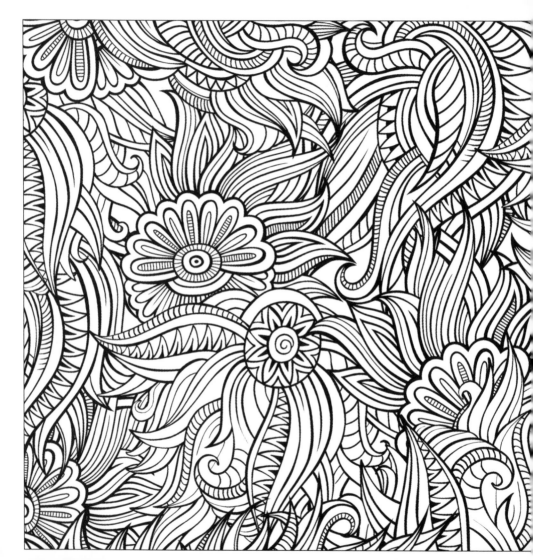

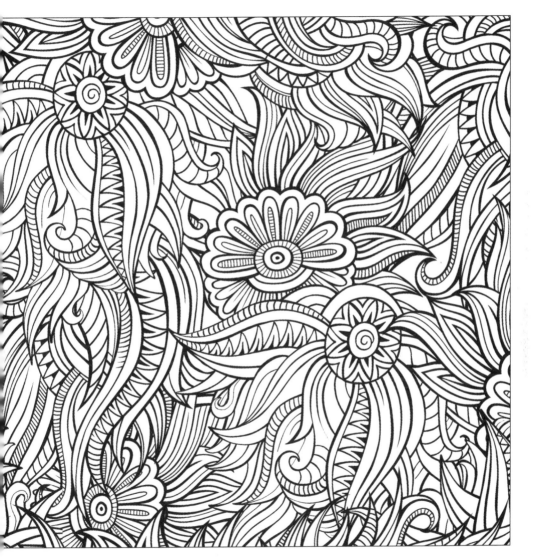

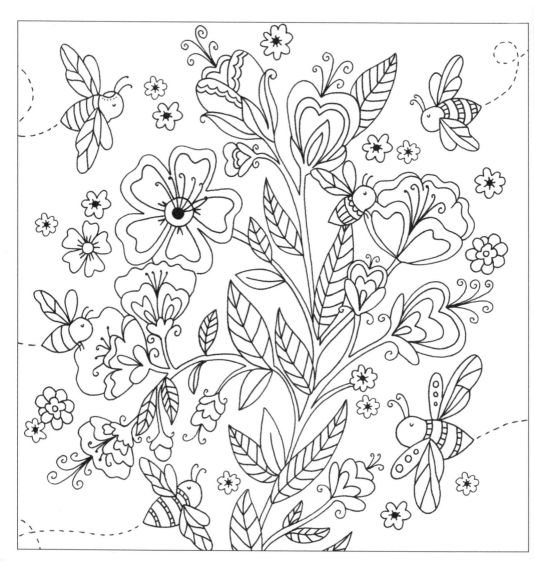

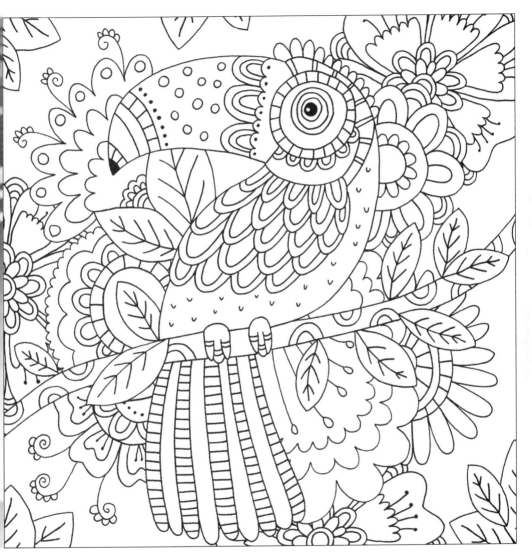

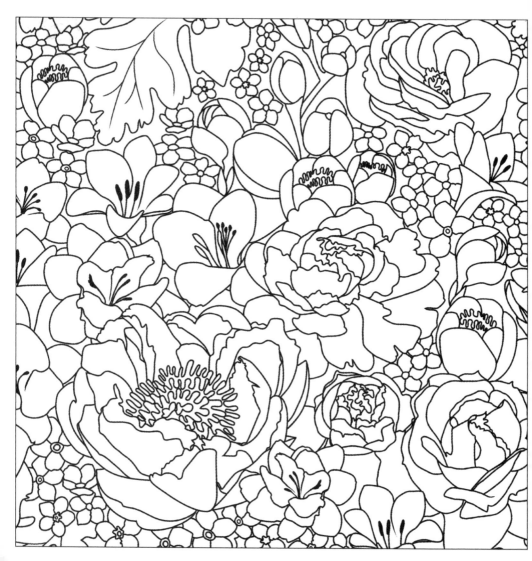

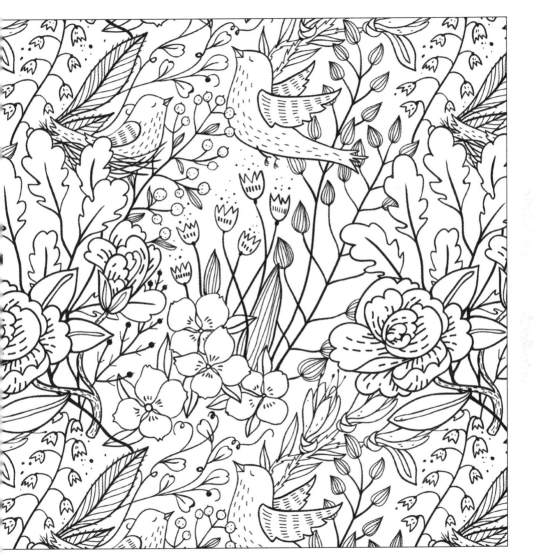

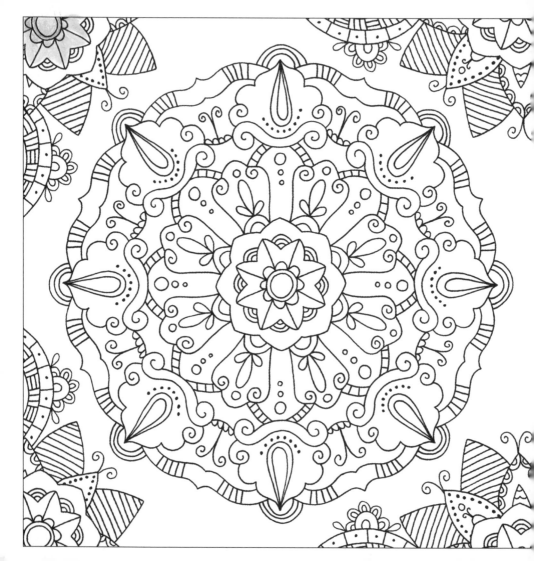

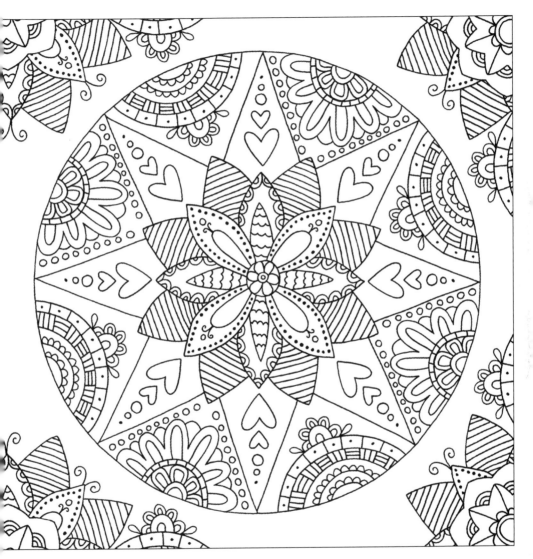

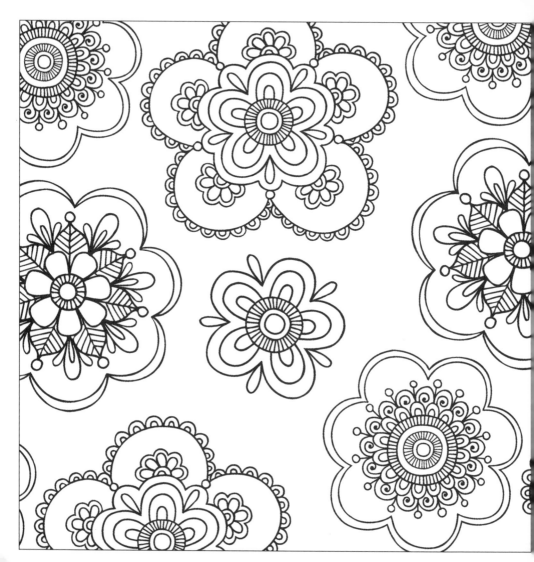

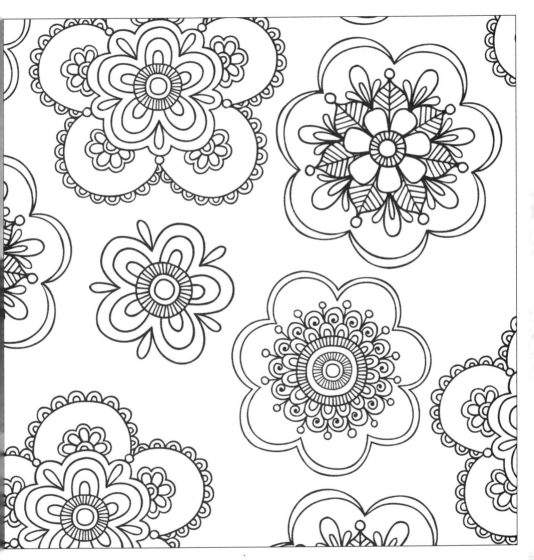

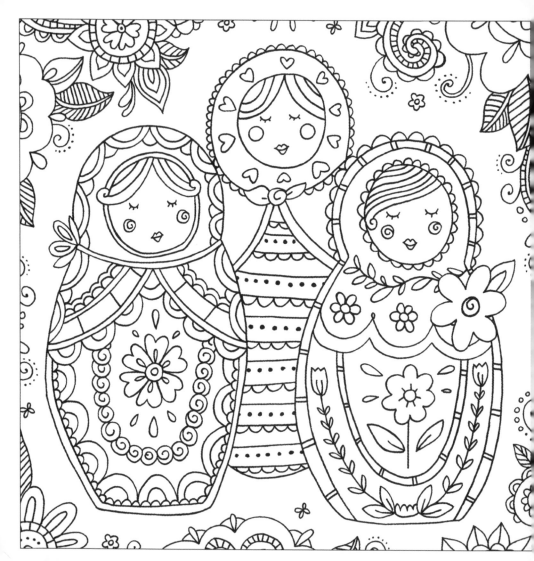

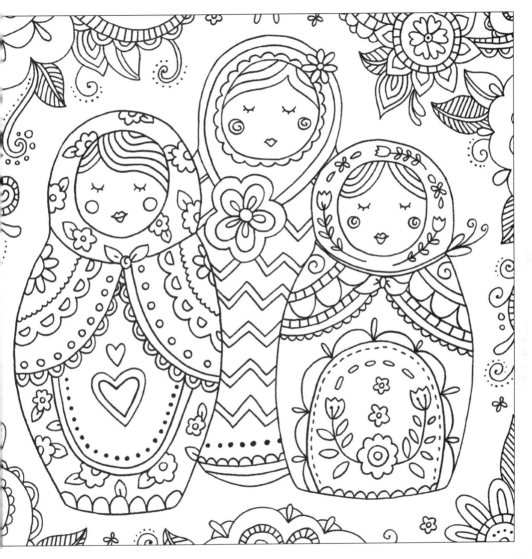

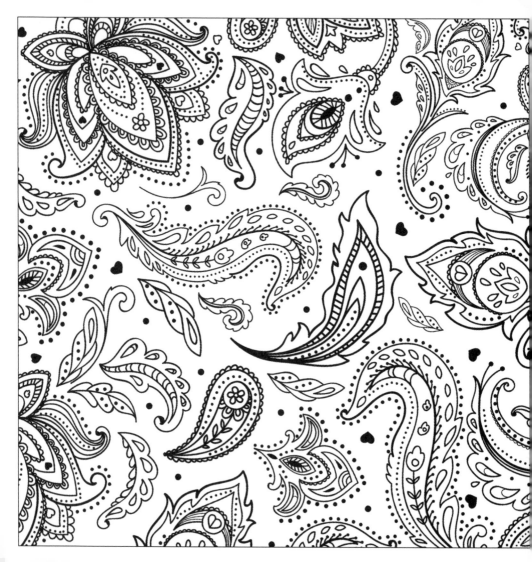

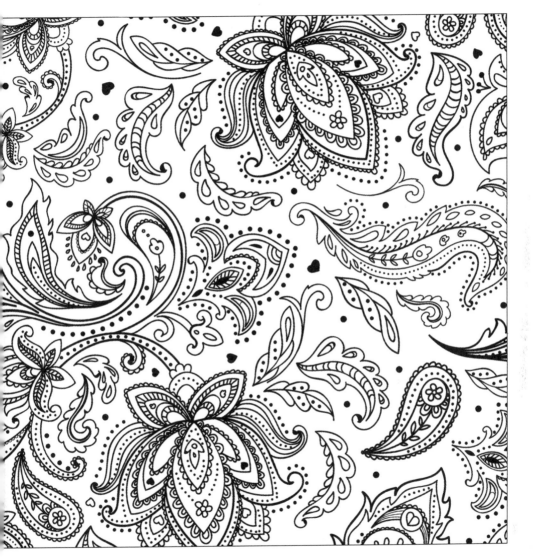

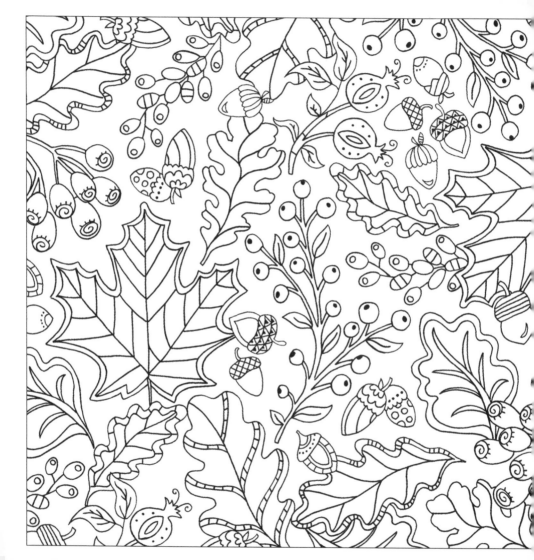

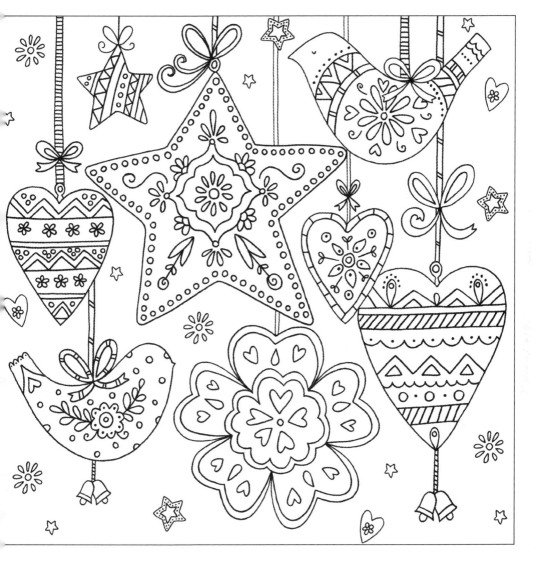

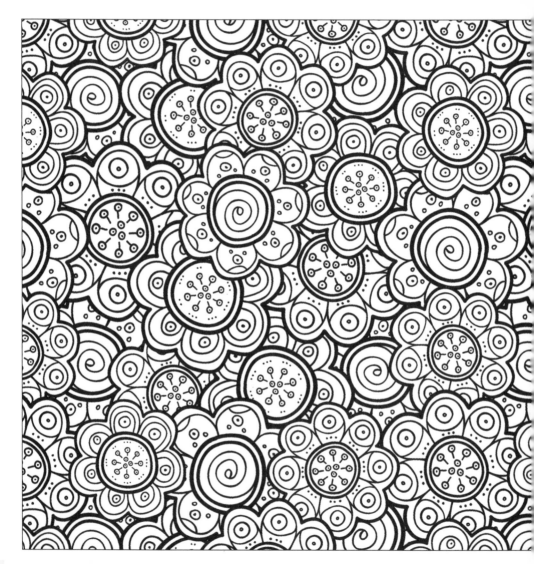

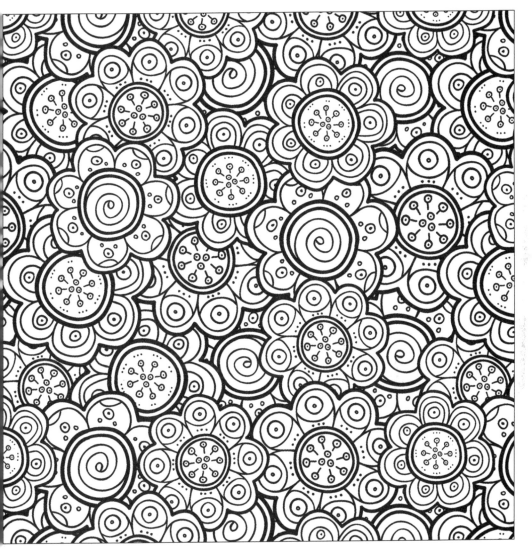

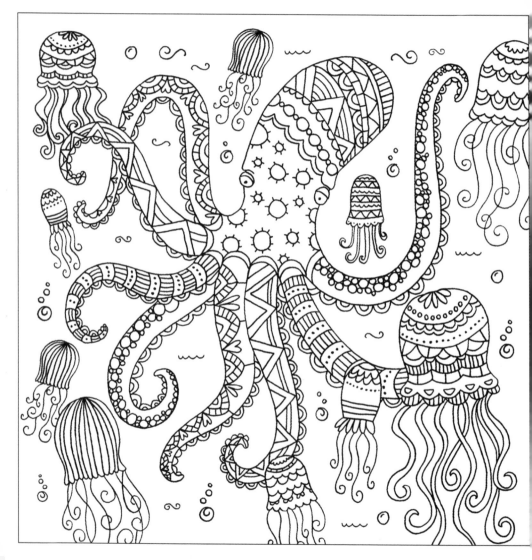

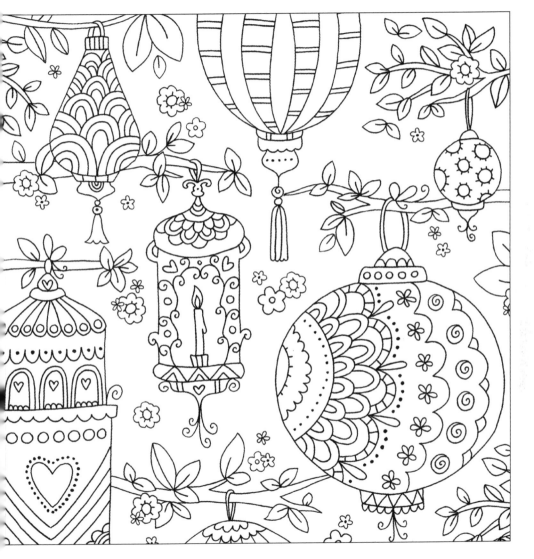

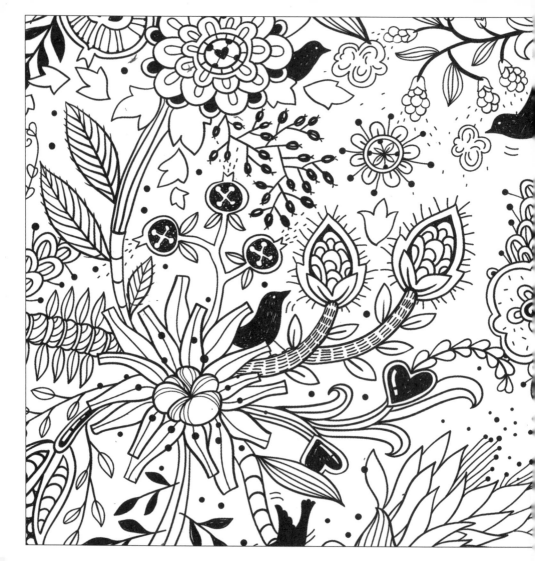

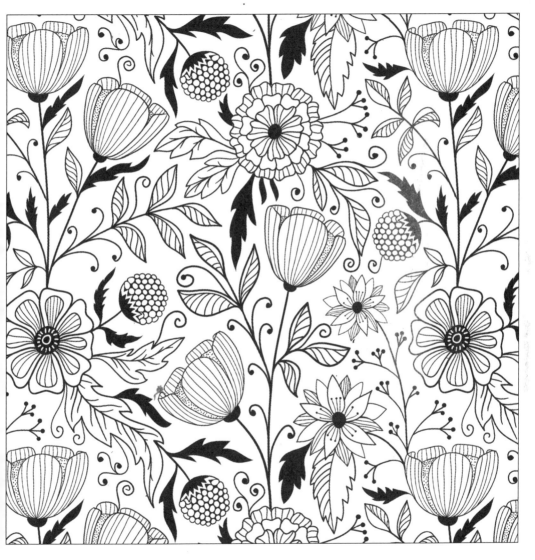

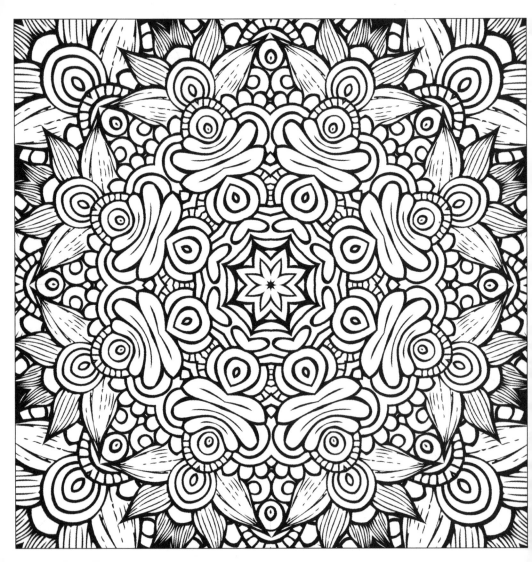

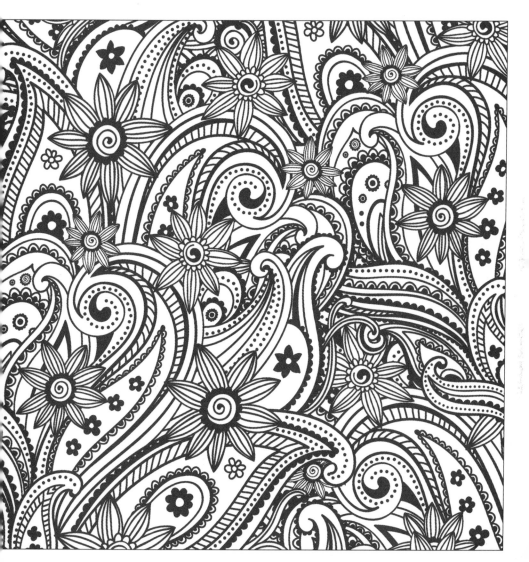

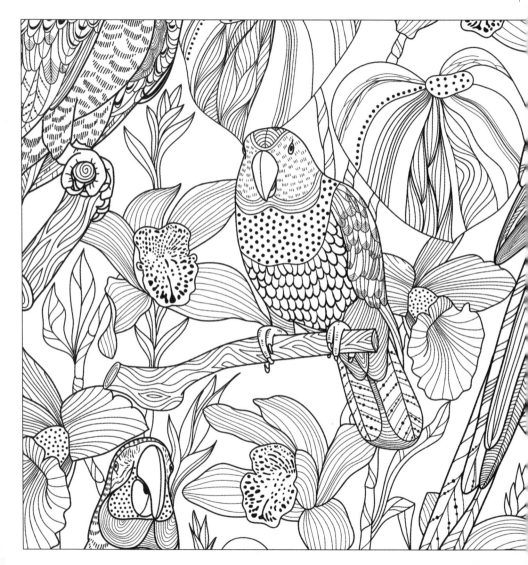

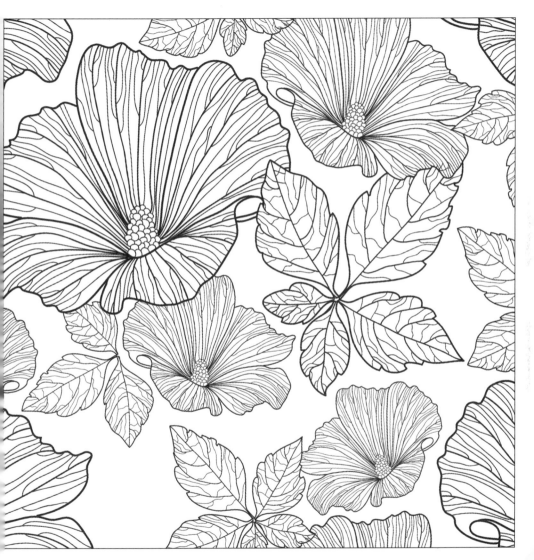

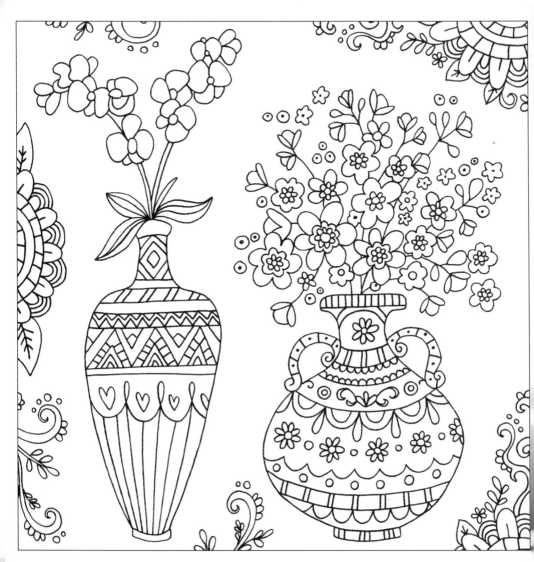

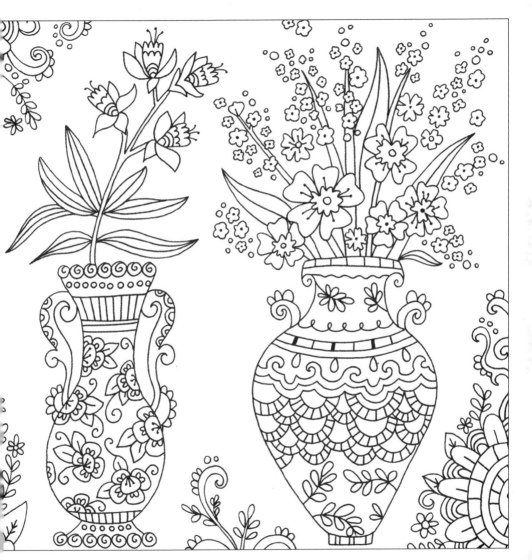

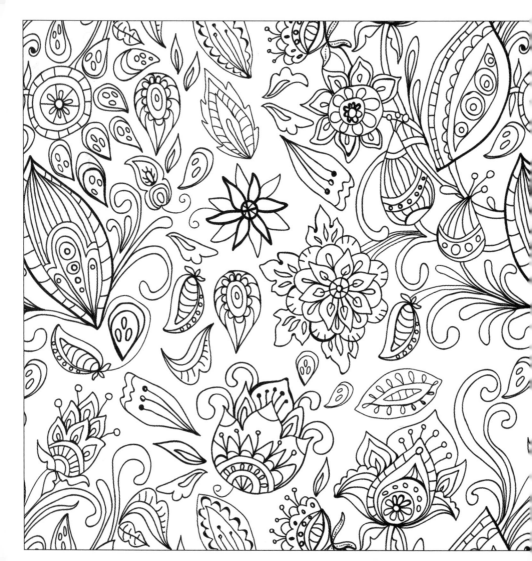

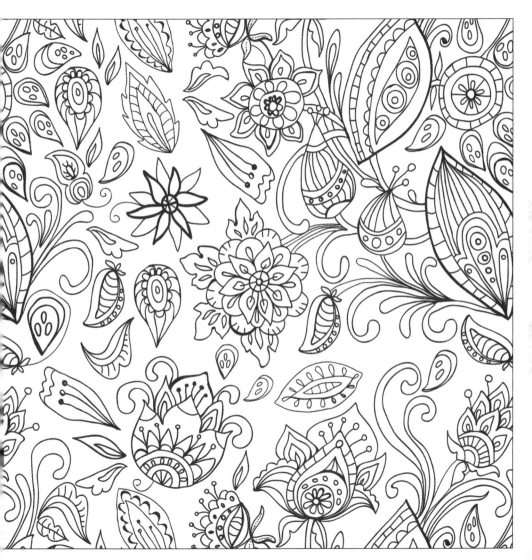

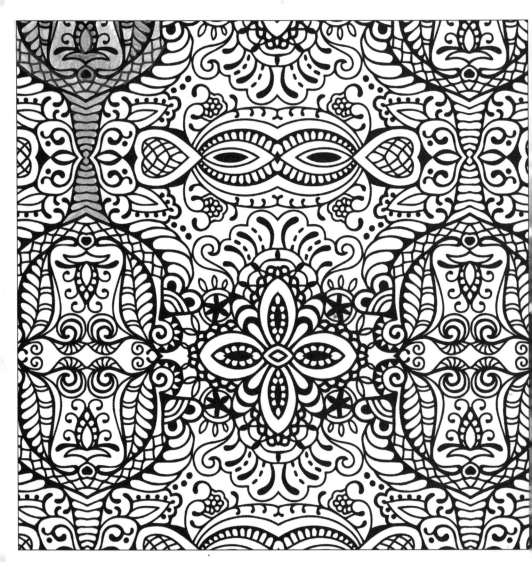

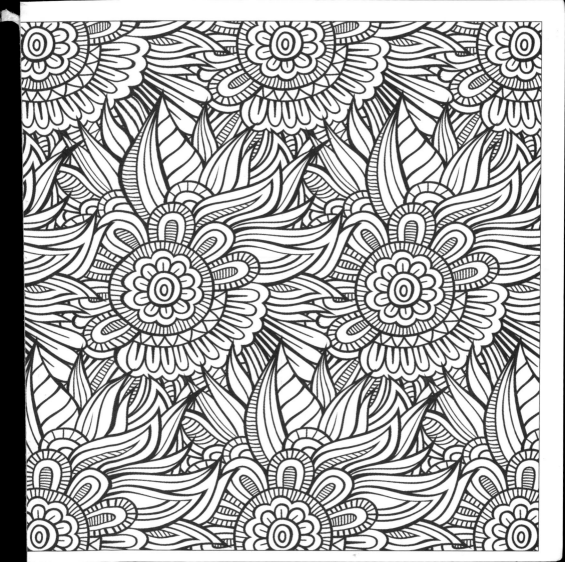

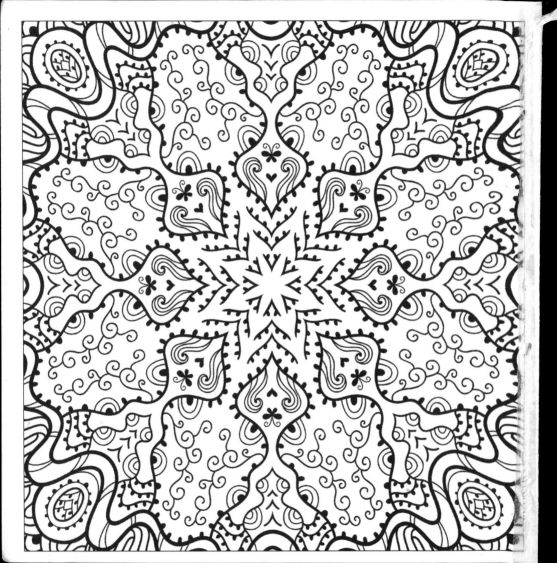